The Rime of the Ancient Mariner

SAMUEL TAYLOR COLERIDGE

illustrations by GUSTAVE DORÉ

with a new introduction
by Millicent Rose

DOVER PUBLICATIONS, INC., NEW YORK

This Dover edition, first published in 1970, is an unabridged and slightly rearranged republication of the work published by Harper & Brothers, Publishers, in New York in 1878. The text of the poem has been compared with that of the 1834 edition, generally considered authoritative, and any significant differences have been altered to conform with that edition. Millicent Rose has written a new Introduction especially for this Dover edition.

DOVER *Pictorial Archive* SERIES

This book belongs to the Dover Pictorial Archive Series. You may use the designs and illustrations for graphics and crafts applications, free and without special permission, provided that you include no more than four in the same publication or project. (For permission for additional use, please write to Dover Publications, Inc., 31 East 2nd Street, Mineola, N.Y. 11501.)

However, republication or reproduction of any illustration by any other graphic service whether it be in a book or in any other design resource is strictly prohibited.

International Standard Book Number: 0-486-22305-1
Library of Congress Catalog Card Number: 70-120848

Manufactured in the United States of America
Dover Publications, Inc.
31 East 2nd Street
Mineola, N.Y. 11501

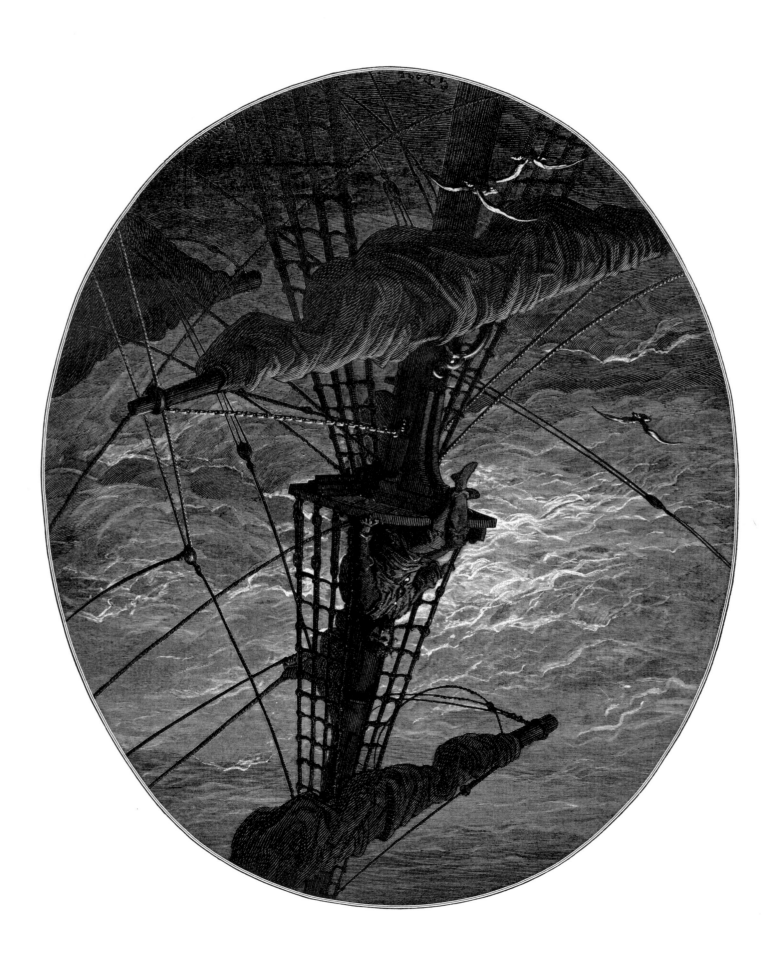

GUSTAVE DORÉ AND
THE RIME OF THE ANCIENT MARINER

Coleridge's *The Rime of the Ancient Mariner* is of all poems surely one of the hardest to illustrate. Its virtues—its subtle music, psychological depths, its sense of growing horror—are not those that ordinarily lend themselves to pictorial representation. Nor would Gustave Doré (1832–1883) seem at first sight the ideal illustrator; he lacked the poet's scholarship and missionary zeal for the new style of poetry Wordsworth and Coleridge brought to the composition of the *Lyrical Ballads*. He shared with Coleridge, however, an exhilarating liberation from the ordinary and everyday; and it was because he was neither learned nor doctrinaire that he could lose himself in the poet's visions. Doré waited all his life to illustrate this poem, and when the time came he produced one of his most inspired works.

Gustave Doré was an Alsatian, born in Strasbourg, in the border country between the Rhine and the long range of the Vosges—a region where one finds a German patois, Teutonic family names, storks nesting on the church towers, beer, sausages and sauerkraut. The Doré family had once spelled their name "Dorer," but by the nineteenth century they had become French and remembered the grandfather who had fought for Napoleon. The father was an engineer, employed by the government in the department of roads and

bridges. Gustave, his second son, was born in January, 1832, in an old house near the great Cathedral. From early childhood the boy loved all that was ancient, quaint and gothic in his birthplace, and was enthralled by the pine forests, the strange legends and spectacular views of the Vosges. In later life he often returned to Alsace for holidays, or painted, from memory, the mountain scenery.

As a young child, Doré began to draw, in the margins of school books or on any scrap of paper that came to hand. His mother and the family servant, Françoise, who helped to bring him up and who was to look after him all his life, were dazzled by the cleverness of these drawings, revealing as they did the child's imagination and his power of catching a likeness. They were convinced that their Gustave was a genius. The father was more practical than they, insisting that the boy should work hard at his lessons and prepare for some profession less precarious than that of an artist. But Mme Doré, who was a typical French materfamilias, handsome and formidable, dominated her family and made her second son her darling. He was small, fair-haired, good-looking and immensely lively. Within the family circle they lived sociably and agreeably. They were all musical: the eldest son Ernest composed a little and played several instruments, flute, piano and trombone, but was persuaded to remain an amateur and take a training in engineering. Gustave, too, made music; he played the violin and had a sweet child's voice which became in due course a light tenor. It was he who was always the centre of fun, at school or at family parties. He was a brilliant gymnast, mimic and conjuror, he made caricature portraits and wrote and illustrated little comic books; all that he did was done with fantastic facility and speed. His childhood was extremely happy, and throughout his adult life he would recall his early exploits, with Arthur Kratz, the schoolfellow who in the years of fame always remained his most intimate friend.

When he was fifteen, Gustave's parents took him with them on a visit to Paris, and there came across the shop of Auber and Philipon, well-known publishers of caricatures and comic magazines. The windows were full of prints, which Gustave studied, realising that this was a genre in which he could make a living, stay in Paris, and escape for good from his father's plans to train him for some conventional profession. While his parents were out on business, he made drawings in the style of those in the shop and took them to M. Philipon; the publisher recognised that here was an exceptional talent and an attractive new personality. He persuaded M. Doré to let the boy stay in Paris and sign a three-year contract.

So Gustave Doré began, at fifteen, the exhausting life of the professional artist in black and white. At first he continued at school; his father placed him at the Lycée Charlemagne

and he boarded with family friends. He is said to have worked seriously at school, though he was a glamorous figure there, for his contributions to Philipon's new paper, the *Journal pour rire*, soon made him famous. In his spare time he haunted the Louvre and the Bibliothèque Nationale, greedily studying the work of other artists, old and modern. There was no time for any formal artistic training. To make up for the lack of life classes, he studied the male nude at the swimming baths, while the marbles and old masters of the Louvre provided him with female models.

He was gifted with an exceptional memory. When not working or studying he went about Paris, memorizing the streets and crowds and all the different kinds of faces and dress. In 1847, many parts of Paris were still picturesquely medieval; Baron Haussmann had not yet cleared away the crooked slums to make new boulevards. The next year, 1848, was the year of revolution. Gustave's attitude to the struggle for power was conservative and negative. The streets full of strife and anger and suffering were for him a splendid place in which to study a subject always fascinating to him: the movement and grouping of crowds.

In 1849 Gustave's father died suddenly of pleurisy. His brother Ernest was nineteen and still an unqualified student of engineering; the younger brother, Emile, a schoolboy of fifteen. There was hardly any money, but Mme Doré's mother had recently left her a roomy old house in the once fashionable quarter of Saint-Germain, rue Saint-Dominique. Mme Doré moved into this house with her family, and at seventeen Gustave became the breadwinner for all of them. The rapid way of working, natural to him, with an ever-present anxiety about money, made him phenomenally productive. For Philipon, to whom he was still under contract, he produced several comic books as well as his journalism, and secretly he also worked for other publishers. He could not bear to turn down a commission. The demand for his work became enormous, and while he began, in his early twenties, the illustrations to the classics for which he will always be remembered, he did not disdain ephemeral journalism or the illustration of novels by Paul de Kock.

From his earliest days in Paris his gaiety and sociability made him a welcome guest at literary and artistic parties, and he soon became a favourite in Second Empire society. The Empress Eugénie herself admired his work and received him. His friends included the ageing Rossini, with whom he made music; Dumas father and son; the photographer Nadar, and many other artists and writers. Théophile Gautier loved him and called him "le gamin de génie"; they visited Spain together, and he became an indispensable part of the amateur theatricals and other gatherings at Gautier's house at Neuilly, amusing the company with his conjuring, acrobatics and such other pranks as his clown's trick

of walking on his hands. He was noted for his recreation, in living tableaux presented by the guests, of paintings, Salon successes, Louvre masterpieces or, as an impromptu compliment, the latest work of some artist who happened to be there. In the rue Saint-Dominique, Mme Doré gave lavish entertainments for her son's distinguished friends. Possessive and philistine, dazzled by fame and greedy for money, she dominated his private life. Though his biographer and friend of later years, Blanche Roosevelt (Mrs. Blanche Roosevelt Tucker Macchetta), hints at an affair with an actress (it was the much-courted Alice Ozy) and says that he made one or two attempts to take a wife, he remained a bachelor to the end of his life.

In the 1850's Doré had almost the monopoly of illustration in Paris. At the beginning of his career he had worked largely in lithograph, drawing upon the stone himself, but in the years of greatest fame nearly all his work was engraved on wood. He used to draw the designs directly upon the blocks, working on several at once and going from one to another with small rapid touches until all were finished. The boxwood was then cut by other hands. As a youth he was always very disappointed by what Philipon's engravers made of his drawings, and in due course he began to work closely with a team of young craftsmen who learned to interpret him more faithfully. They became his friends and served him throughout his career; their signatures—Pisan, Pannemaker, Jonnard and others—may be recognised in his Milton and Dante and are still present years later in *The Rime of the Ancient Mariner*.

He tried in so far as possible to spend only the mornings on the wood blocks which were his living, and to work in the afternoons at another studio where he painted in oils or water-colour. It was his lifelong ambition to become one of the great French painters. Ary Scheffer's brother Henry gave him a start, while Gustave was still in his teens, with the technique of painting in oils, but he was largely self-taught. He painted without discipline and at tremendous speed, often on a very large scale; the results were feebly constructed, muddy in colour and sentimental. The Salon accepted his work but skied it; the critics ignored or slated it and the public preferred the brilliance of Meissonier. Doré was the close contemporary of Manet, Degas, Pissarro but was quite unaware of the new vision being slowly developed by the Impressionists, nor could he (or his mother!) have borne to live the obscure dedicated lives of the Pissarros.

Doré's other aim was to illustrate all the great classics of world literature. Rabelais (1854) and Balzac's *Contes Drôlatiques* (1855, with no less than 425 exquisite drawings) were followed by a multitude of other authors, among them Cervantes, Perrault, La Fontaine, Münchhausen: he was especially at home with the great fairy tales. The interpreta-

tion of Dante, Milton, and the Bible (published in enormous editions in many different languages) to some extent consoled him for his lack of recognition as a painter. During the last ten years of his life he made many designs for an edition of Shakespeare which was never completed.

It was with England and the English writers that the later years of Doré's work were largely concerned. In 1866 he produced an *Idylls of the King* for Moxon, Tennyson's publisher, and in 1867 he was invited to create, in London's New Bond Street, the Doré Gallery, where his paintings could be permanently on show and, as originals or steel engravings, on sale. He began to visit London yearly, and in collaboration with his friend Blanchard Jerrold made a marvellous record of his impressions, *London: A Pilgrimage* (1872). Society received him with enthusiasm; royalty patronised him; he visited Scotland and fell in love with her mountain scenery. But the triumphs as a painter in England were for him always only second-best. A garden party at Chiswick House or Lambeth Palace, country-house visits, or a banquet at the Mansion House offered him neither the bohemian fun of a party with Gautier or Rossini nor the glamorous elegance of the Empress Eugénie and her entourage. However, the Doré Gallery was a sustained success. Beginning as a mixed exhibition, its character became increasingly religious. Towards the end of his life it was dominated by two huge canvases, *Christ Leaving the Praetorium* and the *Entry into Jerusalem*. These and other pictures continued to attract visitors until the gallery came to an end in 1914.

The later years of Doré's life were increasingly melancholy. The Franco-Prussian War was peculiarly sad for him, as the scenes of his Alsatian childhood were now lost to France. He stayed in Paris during the siege, making patriotic cartoons and busying himself on behalf of less influential and wealthy friends. (A minor distress of the war was that five of his pet pugs were stolen and eaten. Four others survived.) The Commune, the peace settlement and the Third Republic were all distasteful to him; the Paris of Napoleon III had gone forever. He had begun to lose the friends of an older generation for whom he had been "le gamin de génie"; Rossini died in 1868, Dumas *père* in 1870, Gautier himself in 1873. Mme Doré was growing old, but she revived their parties in the rue Saint-Dominique, where her son continued to work and play with unabated energy. Busier than ever now, with his paintings for the Doré Gallery, he also began to make sculptures, while the demand for his illustrations continued.

The Rime of the Ancient Mariner is of these last years, and was published in 1875. Doré had a special feeling for the poem, and, in contrast to his usual practice, completed the designs before he made arrangements for publication. He spent lavishly on the blocks,

which were very large, and supervised the engraving with even more than his usual care.

Coleridge did not place *The Ancient Mariner* in any one period; the ballad form suggests olden days and the poem derives partly from the tales of the early explorers. An illustrator must be more precise, and Doré chose a late medieval setting for the wedding feast that begins the poem, with a series of tableaux suggestive of Salon paintings and palpably in fancy dress. As a historian I am irritated by the inconsistencies of costume and puzzled by the musical instruments. But once out with the Mariner to the other side of the world, Doré too "holds us with his glittering eye." Gigantic scale and limitless space had always fascinated Doré; he had played with them in his Rabelais, had evoked the vastness of Dante's Hell and Milton's Chaos. For the Mariner he invents visions even more compelling, of the terrifying space, the storms and whirlpools of an unknown ocean, the vast ice caverns of Antarctica. Nightmare follows the Mariner's crime and the hot sea swarms with monsters. The engraver's textures are imaginatively adapted to evoking the movements of the sea, and there is one wonderful picture (on page 39) of moonrise, in which we are shown not the moon itself but its reflection across a boundless sea, with a tiny ship far away among the waves.

The scenes with figures are perhaps less successful, and not everyone will care for the Spirits in their dainty draperies (pp. 47 ff.). The sailors, however, whether as men or as ghosts, are drawn with all the artist's skill with crowds and his power of individualizing the people in them. There is one touching, humorous scene (page 15) in which the sailors, uncouth and clumsy with cold, offer titbits to the benevolent albatross. Composed with great skill, the illustration shows also that childlike self-surrender to his author that is so special to Doré.

The Mariner returns to a seaport that is French and Gothic, a mixture of Strasbourg Cathedral and the Mont Saint-Michel: the Mariner "stoppeth one of three" in an Alsatian forest. The vision is un-English but coherent and compelling, and it urges one to a re-reading of the poem.

Though Doré himself considered *The Ancient Mariner* one of his "best and most original" works, its sales recouped him only slowly for the great initial outlay. Published first in England, in due course it began to be known, and editions appeared in France, Germany and the United States. It was, Blanche Roosevelt tells us, an outstanding success in America, and the huge brown-and-gold volume with the albatross on the cover was to be found among the family treasures in homes all over the States.

One more illustration of a masterpiece followed the *Ancient Mariner*; this was the *Orlando Furioso* of Ariosto. In his later years Doré was preoccupied with religious paintings and

with sculpture, especially a grand monument to his friend Alexandre Dumas. His mother died after a long illness; for two years he worked on in the big house and still larger studios, cared for by old Françoise and attended by his pet owls. A sudden stroke ended this life of tremendous activity, just as he was preparing for the unveiling of the Dumas monument. He was fifty-one.

The two biographies of Gustave Doré by his contemporaries are both in English, one by his friend Blanche Roosevelt and the other by Blanchard Jerrold, the cosmopolitan English journalist who worked with him on *London: A Pilgrimage*. Jerrold gives an entertaining and sympathetic portrait of Doré as he had known him in Paris and London. Blanche Roosevelt is more gushing, somewhat ingenuous in her admiration for Doré's genius, the splendour of the parties in the rue Saint-Dominique and his successes in London society, but she did in fact know him well, attended his parties and met his friends and family, and after his death visited poor Françoise and talked with her of his early life. The fullest of the French books on Doré is by J. Valmy-Baysse, published in 1930 by Editions Marcel Seheur. It concerns itself with all aspects of his art and is extremely well illustrated. My own monograph was published by the Cresset Press, London, 1946. Doré appears in the *Goncourt Journals* and in Judith Gautier's memoirs, *Le Collier des Jours*.

MILLICENT ROSE

London, 1970

FACILE CREDO, PLURES ESSE NATURAS INVISIBILES QUAM VISIBILES IN RERUM UNIVERSI-
TATE. SED HORUM OMNIUM FAMILIAM QUIS NOBIS ENARRABIT? ET GRADUS ET COGNATIONES
ET DISCRIMINA ET SINGULORUM MUNERA? QUID AGUNT? QUAE LOCA HABITANT? HARUM
RERUM NOTITIAM SEMPER AMBIVIT INGENIUM HUMANUM, NUNQUAM ATTIGIT. JUVAT,
INTEREA, NON DIFFITEOR, QUANDOQUE IN ANIMO, TANQUAM IN TABULA, MAJORIS ET
MELIORIS MUNDI IMAGINEM CONTEMPLARI: NE MENS ASSUEFACTA HODIERNAE VITAE
MINUTIIS SE CONTRAHAT NIMIS, ET TOTA SUBSIDAT IN PUSILLAS COGITATIONES. SED
VERITATI INTEREA INVIGILANDUM EST, MODUSQUE SERVANDUS, UT CERTA AB INCERTIS,
DIEM A NOCTE, DISTINGUAMUS.—T. BURNET, *Archaeol. Phil.* p. 68.

I readily believe that there are more invisible Natures in the universe than visible ones.
Yet who shall explain to us this numerous company, their grades, their relationships,
their distinguishing features and the functions of each of them? What do they do?
What places do they inhabit? The human intellect has always sought for knowledge
of these matters, but has never attained it. Nevertheless, I do not deny that it is pleasing
now and then to contemplate in the mind, as if in a picture, the image of a greater and
better world, in order that our intelligence, grown accustomed to the trifles of modern
life, may not shrink too drastically and become totally submerged in petty reflections.
Nevertheless, we must pay heed to truth and keep a just measure, so that we can dis-
tinguish sure things from uncertain, day from night.—T. BURNET, *Archaeologiae Phil-
osophicae sive Doctrina Antiqua De Rerum Originibus.* Libri Duo: Londini, MDCXCII, p. 68.

The Rime
of the Ancient Mariner

IN SEVEN PARTS

PART
THE FIRST

*An ancient
Mariner meeteth
three Gallants
bidden to a
wedding-feast,
and detaineth
one.*

IT is an ancient Mariner, [*ancient Mariner*]
And he stoppeth one of three. [*Epithets*]
"By thy long grey beard and glittering eye,
Now wherefore stopp'st thou me? [*an Epic suggested by the epithets*]

"The Bridegroom's doors are opened wide,
And I am next of kin;
The guests are met, the feast is set:
May'st hear the merry din."

He holds him with his skinny hand,
"There was a ship," quoth he.
"Hold off! unhand me, grey-beard loon!"
Eftsoons his hand dropt he.

2

He holds him with his glittering eye—
The Wedding-Guest stood still,
And listens like a three years' child:
The Mariner hath his will.

The Wedding-Guest sat on a stone:
He cannot choose but hear;
And thus spake on that ancient man,
The bright-eyed Mariner.

Probably takes place in Scotland

The ship was cheered, the harbor cleared,
Merrily did we drop
Prespeterian church, Scottish Church
Below the kirk, below the hill,
Below the light-house top. *all four are symbolizing safety*

The Sun came up upon the left,
Out of the sea came he!
And he shone bright, and on the right
Went down into the sea.

Higher and higher every day,
Till over the mast at noon—
The Wedding-Guest here beat his breast,
For he heard the loud bassoon.

The Wedding-
Guest heareth
the bridal mu-
sic ; but the
Mariner contin-
ueth his tale.

The bride hath paced into the hall,
Red as a rose is she ;
Nodding their heads before her goes
The merry minstrelsy.

The Wedding-Guest he beat his breast,
Yet he cannot choose but hear ;
And thus spake on that ancient man,
The bright-eyed Mariner.

And now the STORM-BLAST came, and he
Was tyrannous and strong :
He struck with his o'ertaking wings,
And chased us south along.

a huge storm

With sloping masts and dipping prow,
As who pursued with yell and blow
Still treads the shadow of his foe,
And forward bends his head,
The ship drove fast, loud roared the blast,
And southward aye we fled.

8

Antarctica And now there came both <u>mist and snow</u>,
And it grew wondrous cold:
And ice, mast-high, came floating by,
As green as emerald.

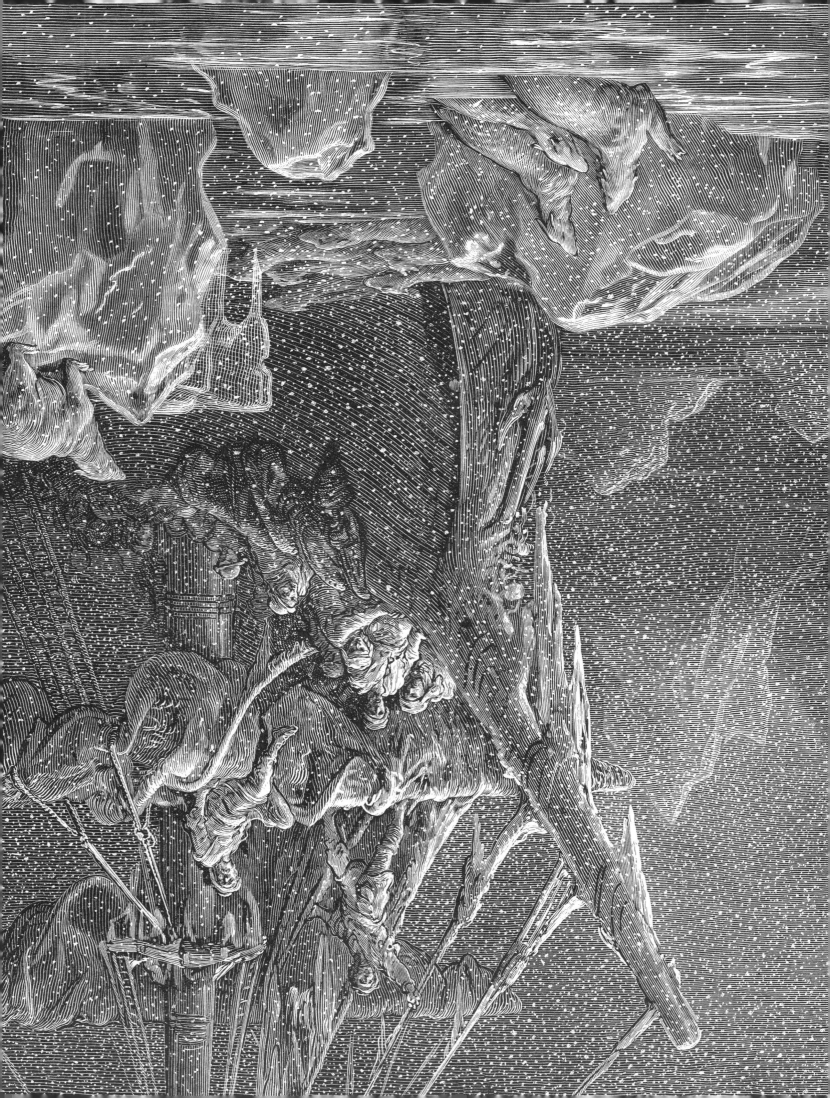

The land of ice, and of fearful sounds, where no living thing was to be seen.

And through the drifts the snowy clifts
Did send a dismal sheen:
Nor shapes of men nor beasts we ken—
The ice was all between.

The ice was here, the ice was there,
The ice was all around:
It cracked and growled, and roared and howled,
Like noises in a swound!

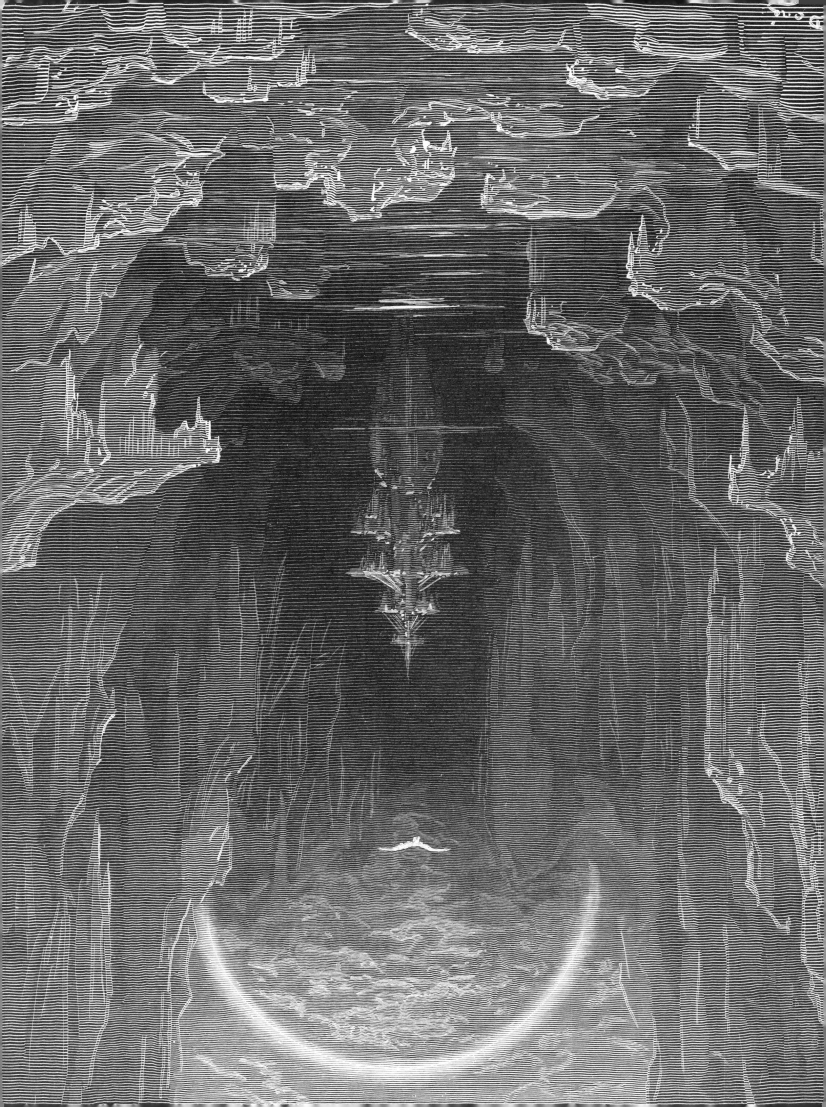

a good omen, and then it becomes a bad omen

Till a great sea-bird, called the Albatross, came through the snow-fog, and was received with great joy and hospitality.

At length did cross an Albatross,
Thorough the fog it came;
As if it had been a Christian soul,
We hailed it in God's name.

It ate the food it ne'er had eat,
And round and round it flew.
The ice did split with a thunder-fit;
The helmsman steered us through!

And lo! the Albatross proveth a bird of good omen, and followeth the ship as it returned northward through fog and floating ice.

And a good south wind sprung up behind;
The Albatross did follow,
And every day, for food or play,
Came to the mariners' hollo!

In mist or cloud, on mast or shroud,
It perched for vespers nine;
Whiles all the night, through fog-smoke white,
Glimmered the white Moon-shine.

The ancient Mariner inhospitably killeth the pious bird of good omen.

he could have killed the bird out of many reasons

"God save thee, ancient Mariner!
From the fiends, that plague thee thus!—
Why look'st thou so?"—With my cross-bow
I shot the ALBATROSS.

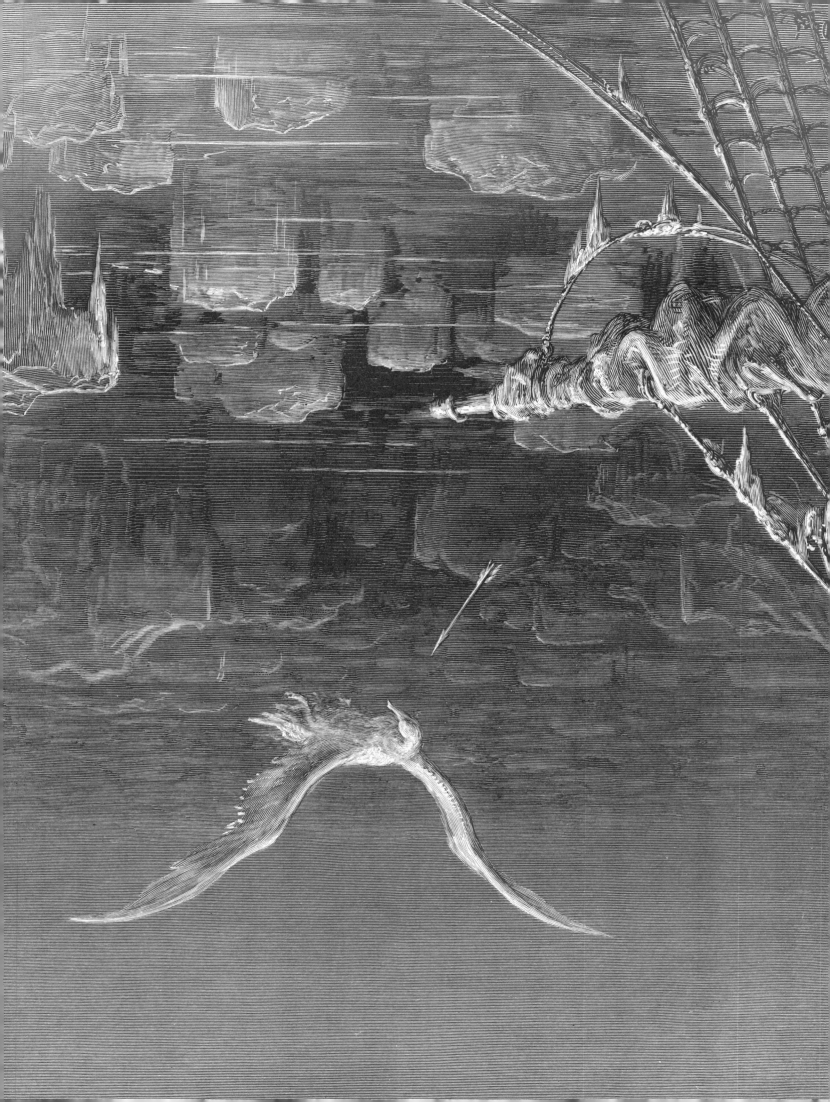

PART
THE SECOND

*His shipmates
cry out against
the ancient
Mariner, for
killing the bird
of good luck.*

T HE Sun now rose upon the right:
Out of the sea came he,
Still hid in mist, and on the left
Went down into the sea.

And the good south wind still blew behind,
But no sweet bird did follow,
Nor any day for food or play
Came to the mariners' hollo!

And I had done a hellish thing,
And it would work 'em woe:
For all averred, I had killed the bird
That made the breeze to blow.
Ah wretch! said they, the bird to slay,
That made the breeze to blow!

The bird brought
The breeze and
wind; all said it
was a bad thing to
kill the bird

18

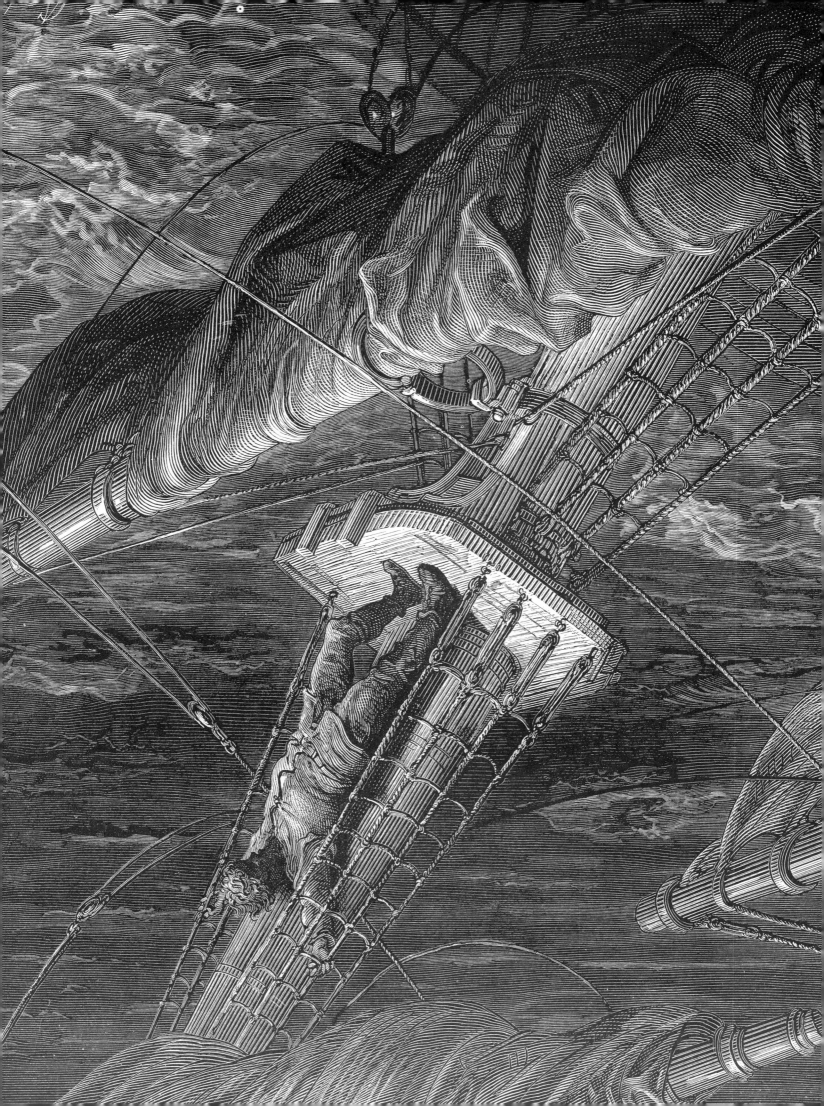

But when the fog cleared off, they justify the same, and thus make themselves accomplices in the crime.

Nor dim nor red, like God's own head,
The glorious Sun uprist:
Then all averred, I had killed the bird
That brought the fog and mist.
'Twas right, said they, such birds to slay,
That bring the fog and mist.

The fair breeze continues; the ship enters the Pacific Ocean, and sails northward, even till it reaches the line.

The fair breeze blew, the white foam flew,
The furrow followed free;
We were the first that ever burst
Into that silent sea.

The ship hath been suddenly becalmed.

Down dropt the breeze, the sails dropt down,
'Twas sad as sad could be;
And we did speak only to break
The silence of the sea!

All in a hot and copper sky,
The bloody Sun, at noon,
Right up above the mast did stand,
No bigger than the Moon.

Day after day, day after day,
We stuck, nor breath nor motion;
As idle as a painted ship
Upon a painted ocean.

And the Albatross begins to be avenged.

Water, water, every where,
And all the boards did shrink;
Water, water, every where,
Nor any drop to drink.

The very deep did rot: O Christ!
That ever this should be!
Yea, slimy things did crawl with legs
Upon the slimy sea.

About, about, in reel and rout,
The death-fires danced at night;
The water, like a witch's oils,
Burnt green, and blue and white.

an evil Spirit

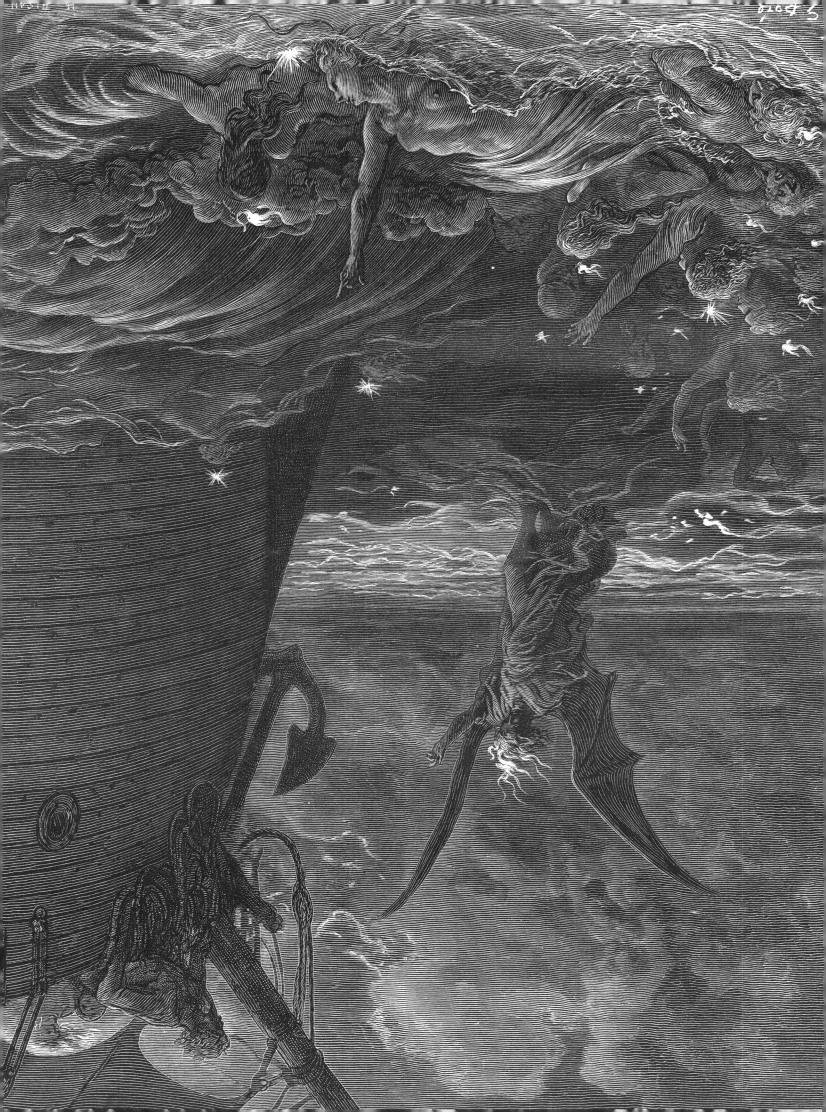

And some in dreams assuréd were
Of the Spirit that plagued us so;
Nine fathom deep he had followed us
From the land of mist and snow.

And every tongue, through utter drought,
Was withered at the root;
We could not speak, no more than if
We had been choked with soot.

Ah! well-a-day! what evil looks
Had I from old and young!
Instead of the cross, the Albatross
About my neck was hung.

a religious man because he imagined the cross on his neck

PART THE THIRD

The ancient Mariner be- holdeth a sign in the element afar off.

THERE passed a weary time. Each throat
Was parched, and glazed each eye.
A weary time! a weary time!
How glazed each weary eye,
When looking westward, I beheld
A something in the sky.

At first it seemed a little speck,
And then it seemed a mist;
It moved and moved, and took at last
A certain shape, I wist.

24

A speck, a mist, a shape, I wist!
And still it neared and neared:
As if it dodged a water-sprite,
It plunged and tacked and veered.

At its nearer approach, it seemeth him to be a ship; and at a dear ransom he freeth his speech from the bonds of thirst.

With throats unslaked, with black lips baked,
We could nor laugh nor wail;
Through utter drought all dumb we stood!
I bit my arm, I sucked the blood,
And cried, A sail! a sail! a boat

A flash of joy;

With throats unslaked, with black lips baked,
Agape they heard me call:
Gramercy! they for joy did grin,
And all at once their breath drew in,
As they were drinking all.

And horror follows. For can it be a ship that comes onward without wind or tide?

See! see! (I cried) she tacks no more!
Hither to work us weal;
Without a breeze, without a tide,
She steadies with upright keel!

The western wave was all a-flame,
The day was well nigh done!
Almost upon the western wave time of day
Rested the broad bright Sun;
When that strange shape drove suddenly
Betwixt us and the Sun.

It seemeth him but the skeleton of a ship.

And straight the Sun was flecked with bars
(Heaven's Mother send us grace!),
As if through a dungeon-grate he peered
With broad and burning face. sunburn

Alas! (thought I, and my heart beat loud)
How fast she nears and nears!
Are those her sails that glance in the Sun,
Like restless gossameres?

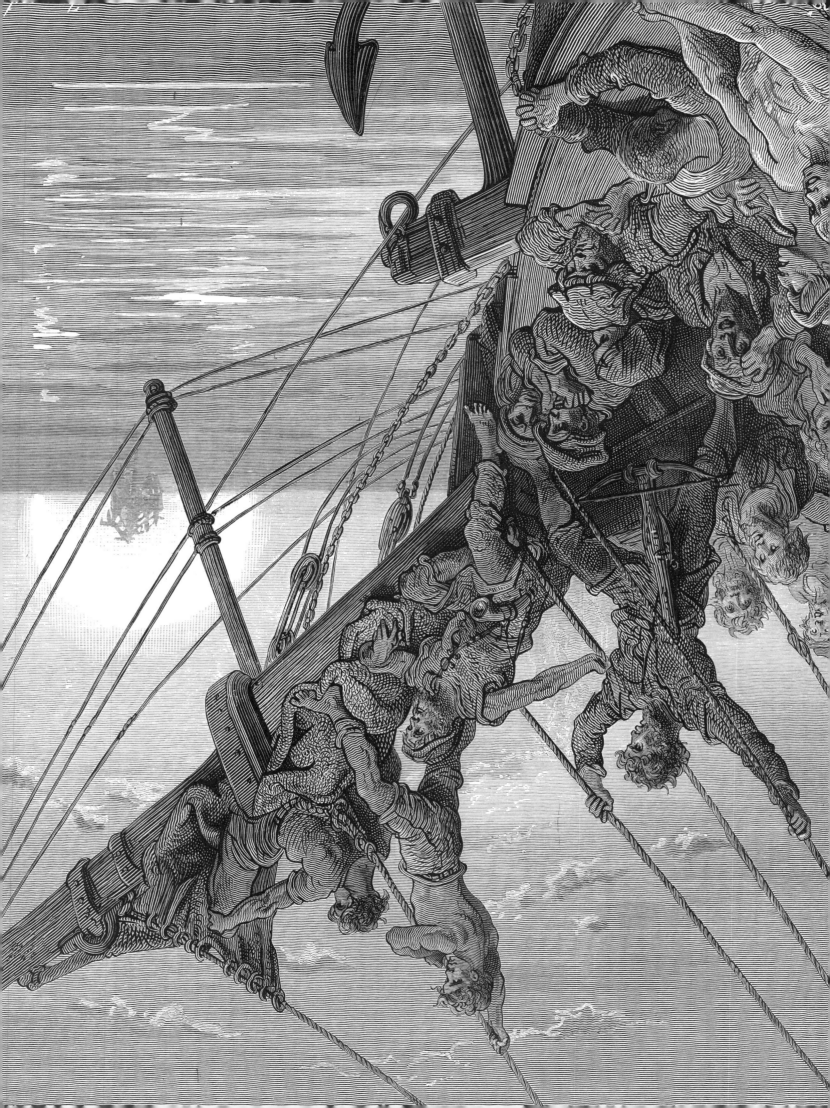

And its ribs are seen as bars on the face of the setting Sun. The Spectre-Woman and her Death-mate, and no other, on board the skele-ton-ship.

Are those her ribs through which the Sun
Did peer, as through a grate?
And is that Woman all her crew?
Is that a DEATH? and are there two?
Is DEATH that Woman's mate?

[handwritten: The Woman is Life]

[handwritten: The names are capatalized] *[handwritten: Woman's name is capatalized]* *[handwritten: a ship mate or married mate]*

[handwritten: Death has no set gender, but usually a male] *Like vessel, like crew!*

Her lips were red, her looks were free,
Her locks were yellow as gold:
Her skin was as white as leprosy,
The Nightmare LIFE-IN-DEATH was she,
Who thicks man's blood with cold.

*[handwritten: Life-In-Death
- imortality
- twisted imortality]*

DEATH and LIFE-IN-DEATH have diced for the ship's crew, and she (the latter) winneth the ancient Mariner.

The naked hulk alongside came,
And the twain were casting dice;
"The game is done! I've won, I've won!"
Quoth she, and whistles thrice.

[handwritten: Life & Death are playing a game of dice and gambling for the souls of everyone on the ship]

No twilight within the courts of the Sun.

The Sun's rim dips; the stars rush out:
At one stride comes the Dark;
With far-heard whisper, o'er the sea,
Off shot the spectre-bark.

We listened and looked sideways up!
Fear at my heart, as at a cup,
My life-blood seemed to sip!
The stars were dim, and thick the night,
The steersman's face by his lamp gleamed white;

At the rising of the Moon,

From the sails the dew did drip—
Till clomb above the eastern bar
The hornéd Moon, with one bright star
Within the nether tip.

One after another, his creumen died one by one

One after one, by the star-dogged Moon,
Too quick for groan or sigh,
Each turned his face with a ghastly pang,
And cursed me with his eye.

Four times fifty living men 200 men
(And I heard nor sigh nor groan),
With heavy thump, a lifeless lump,
They dropped down one by one.

His shipmates drop down dead;

The souls did from their bodies fly—
They fled to bliss or woe!

But LIFE-IN-DEATH *begins her work on the ancient Mariner.*

And every soul it passed me by,
Like the whiz of my CROSS-BOW!

PART
THE FOURTH

The Wedding-Guest feareth that a Spirit is talking to him;

But the ancient Mariner assureth him of his bodily life, and proceedeth to relate his horrible penance.

" I FEAR thee, ancient Mariner !
 I fear thy skinny hand !
And thou art long, and lank, and brown,
As is the ribbed sea-sand.

" I fear thee and thy glittering eye,
And thy skinny hand, so brown."— *Wedding-Guest is speaking to the Ancient Mariner*
Fear not, fear not, thou Wedding-Guest !
This body dropt not down.
 imortality keeps him alive

Alone, alone, all, all alone,
Alone on a wide wide sea !
And never a saint took pity on
My soul in agony.

*He despiseth
the creatures of
the calm,*

The many men, so beautiful!
And they all dead did lie:
And a thousand thousand slimy things
Lived on; and so did I.

*And envieth
that they
should live,
and so many
lie dead.*

I looked upon the rotting sea,
And drew my eyes away;
I looked upon the rotting deck,
And there the dead men lay.

Death is every where

I looked to heaven, and tried to pray;
But or ever a prayer had gusht,
A wicked whisper came, and made
My heart as dry as dust.

Whisper kept him from preying

I closed my lids, and kept them close,
And the balls like pulses beat;
For the sky and the sea, and the sea and the sky,
Lay like a load on my weary eye,
And the dead were at my feet.

Judeo-Christian
Process of
1) sin
2) suffer
3) penance (confession)
4) forgiveness

God will not forgive
him yet; he (Manner)
is in between suffer
and penance

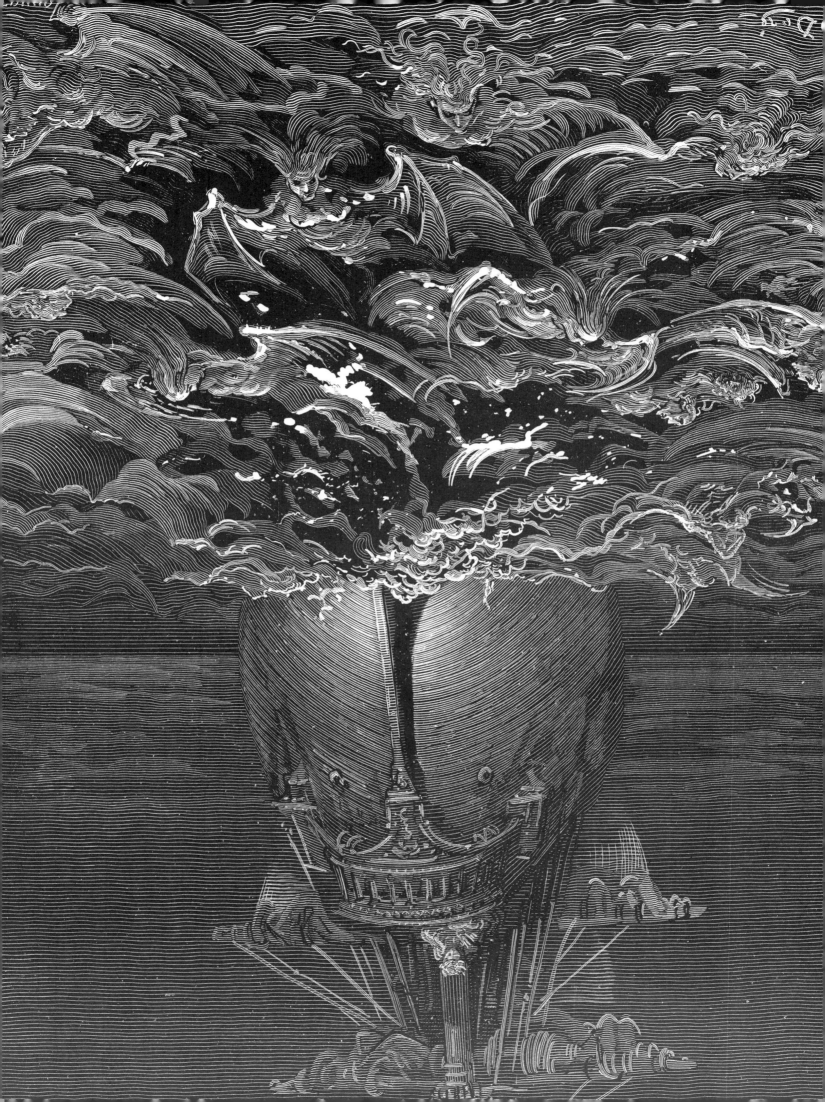

God making him pay
his penance

a constant reminder
of what happened to
his shipmates because
of him

The cold sweat melted from their limbs,
Nor rot nor reek did they:
The look with which they looked on me
Had never passed away.

An orphan's curse would drag to Hell
A spirit from on high;
But oh! more horrible than that
Is the curse in a dead man's eye!
Seven days, seven nights, I saw that curse,
And yet I could not die.

God
creates the Earth
in 7 days and
7 Nights

*In his loneli-
ness and
fixedness he
yearneth to-
ward the jour-
neying Moon,
and the stars
that still so-
journ, yet still
move onward;
and every
where the blue
sky belongs
to them, and is
their appointed
rest, and their
native country
and their own
natural homes,
which they
enter unan-
nounced, as
lords that are
certainly ex-
pected, and yet
there is a silent
joy at their
arrival.*

The moving Moon went up the sky,
And nowhere did abide:
Softly she was going up,
And a star or two beside—

Her beams bemocked the sultry main,
Like April hoar-frost spread;
But where the ship's huge shadow lay,
The charmèd water burnt alway
A still and awful red.

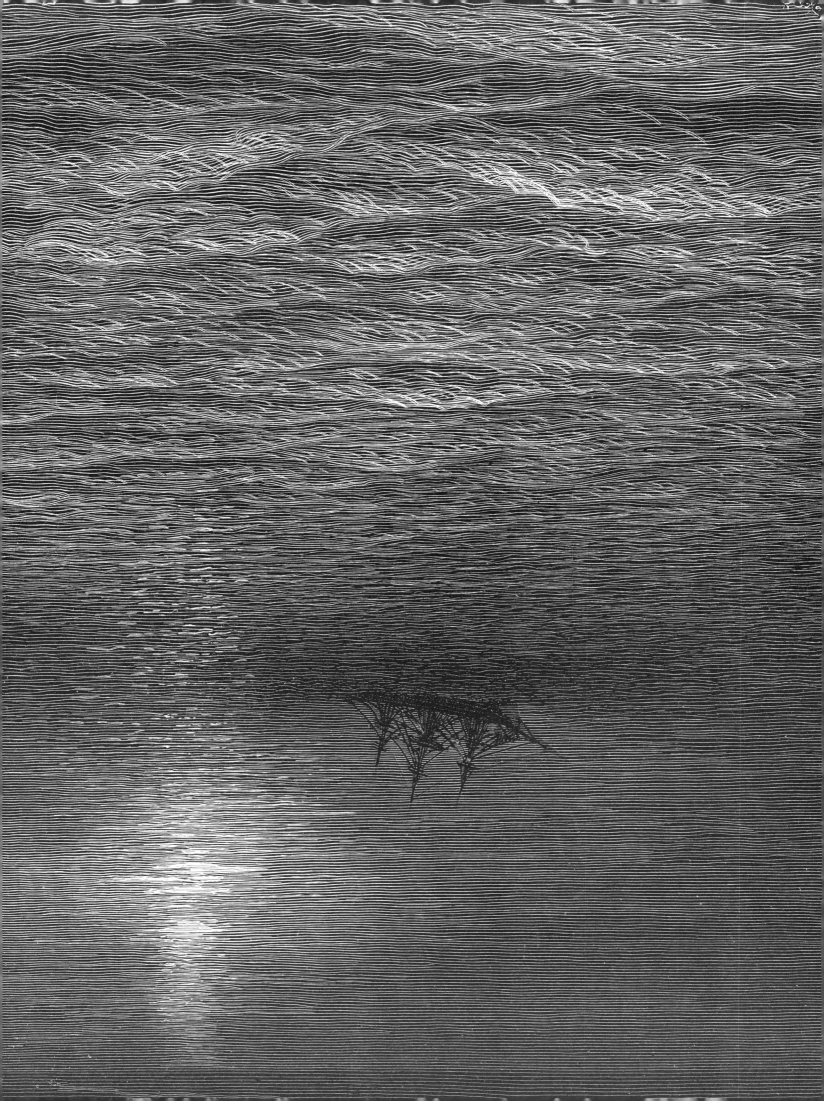

His ship is not
going anywhere
• Doldrum
 – no wind to move
 a sailing ship
 – extreme boredum;
 stuck in a rut

By the light of the Moon he beholdeth God's creatures of the great calm.

Beyond the shadow of the ship,
I watched the water-snakes:
They moved in tracks of shining white,
And when they reared, the elfish light
Fell off in hoary flakes.

Within the shadow of the ship
I watched their rich attire:
Blue, glossy green, and velvet black,
They coiled and swam; and every track
Was a flash of golden fire.

Their beauty and their happiness.

Being forgiven
he was able to pray
again

He blesseth them in his heart.

O happy living things! no tongue
Their beauty might declare:
A spring of love gushed from my heart,
And I blessed them unaware:
Sure my kind saint took pity on me,
And I blessed them unaware.

after praying
the bird fell off

he was freed
from his
crime; he
was forgiven

The spell begins to break.

The self-same moment I could pray;
And from my neck so free
The Albatross fell off, and sank
Like lead into the sea.

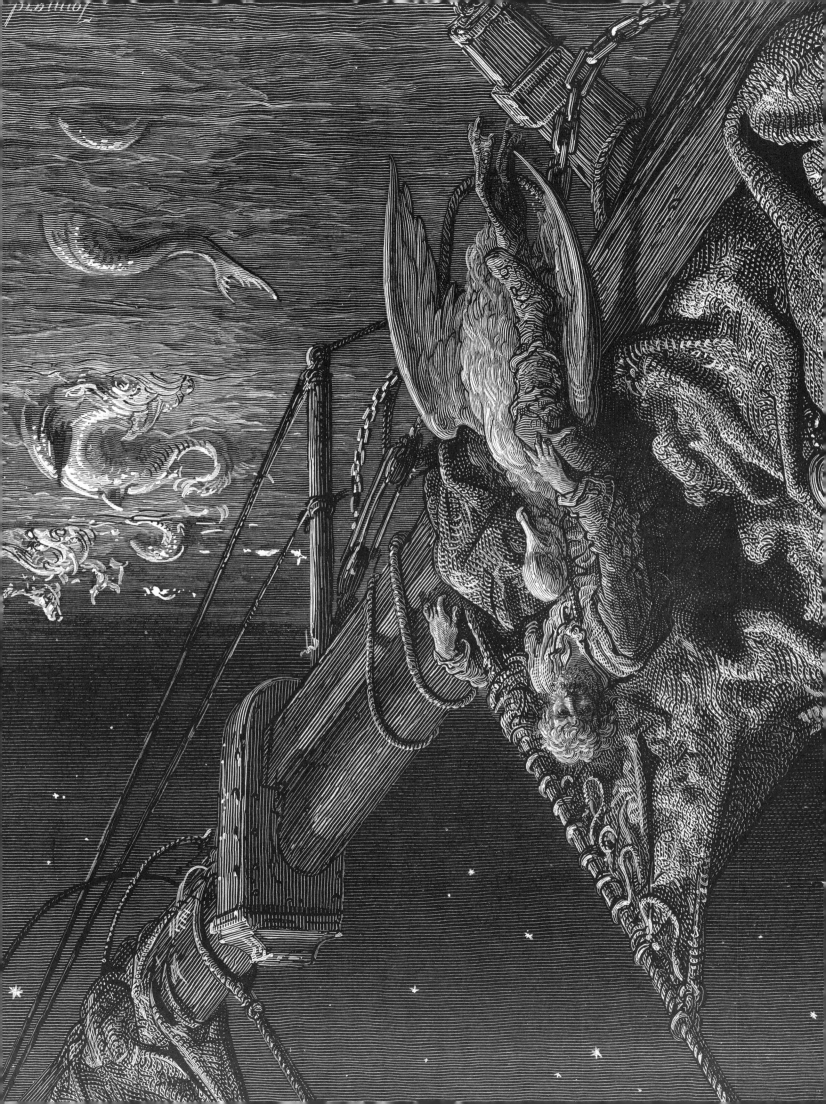

PART THE FIFTH

OH sleep! it is a gentle thing,
 Beloved from pole to pole!
To Mary Queen the praise be given!
She sent the gentle sleep from Heaven,
 That slid into my soul.

The silly buckets on the deck,
 That had so long remained,
I dreamt that they were filled with dew;
And when I awoke, it rained.

My lips were wet, my throat was cold,
 My garments all were dank;
Sure I had drunken in my dreams,
 And still my body drank.

I moved, and could not feel my limbs:
 I was so light—almost
I thought that I had died in sleep,
 And was a blesséd ghost.

And soon I heard a roaring wind:
 It did not come anear;
But with its sound it shook the sails,
 That were so thin and sere.

The upper air burst into life!
 And a hundred fire-flags sheen,
To and fro they were hurried about!
And to and fro, and in and out,
 The wan stars danced between.

And the coming wind did roar more loud,
 And the sails did sigh like sedge;
And the rain poured down from one black cloud;
 The Moon was at its edge.

The thick black cloud was cleft, and still
 The Moon was at its side:
Like waters shot from some high crag,
The lightning fell with never a jag,
 A river steep and wide.

The loud wind never reached the ship,
Yet now the ship moved on!
Beneath the lightning and the Moon
The dead men gave a groan.

They groaned, they stirred, they all uprose,
Nor spake, nor moved their eyes:
It had been strange, even in a dream,
To have seen those dead men rise.

The helmsman steered, the ship moved on;
Yet never a breeze up-blew!
The mariners all 'gan work the ropes,
Where they were wont to do:
They raised their limbs like lifeless tools—
We were a ghastly crew.

The body of my brother's son
Stood by me, knee to knee:
The body and I pulled at one rope,
But he said nought to me.

"I fear thee, ancient Mariner!"
Be calm, thou Wedding-Guest!
'Twas not those souls that fled in pain,
Which to their corses came again,
But a troop of spirits blest:

For when it dawned—they dropped their arms,
And clustered round the mast;
Sweet sounds rose slowly through their mouths,
And from their bodies passed.

Around, around, flew each sweet sound,
Then darted to the Sun;
Slowly the sounds came back again,
Now mixed, now one by one.

Sometimes a-dropping from the sky
I heard the sky-lark sing;
Sometimes all little birds that are,
How they seemed to fill the sea and air
With their sweet jargoning!

And now 'twas like all instruments,
Now like a lonely flute;
And now it is an angel's song,
That makes the Heavens be mute.

It ceased; yet still the sails made on
A pleasant noise till noon,
A noise like of a hidden brook
In the leafy month of June,
That to the sleeping woods all night
Singeth a quiet tune.

Till noon we quietly sailed on,
Yet never a breeze did breathe:
Slowly and smoothly went the ship,
Moved onward from beneath.

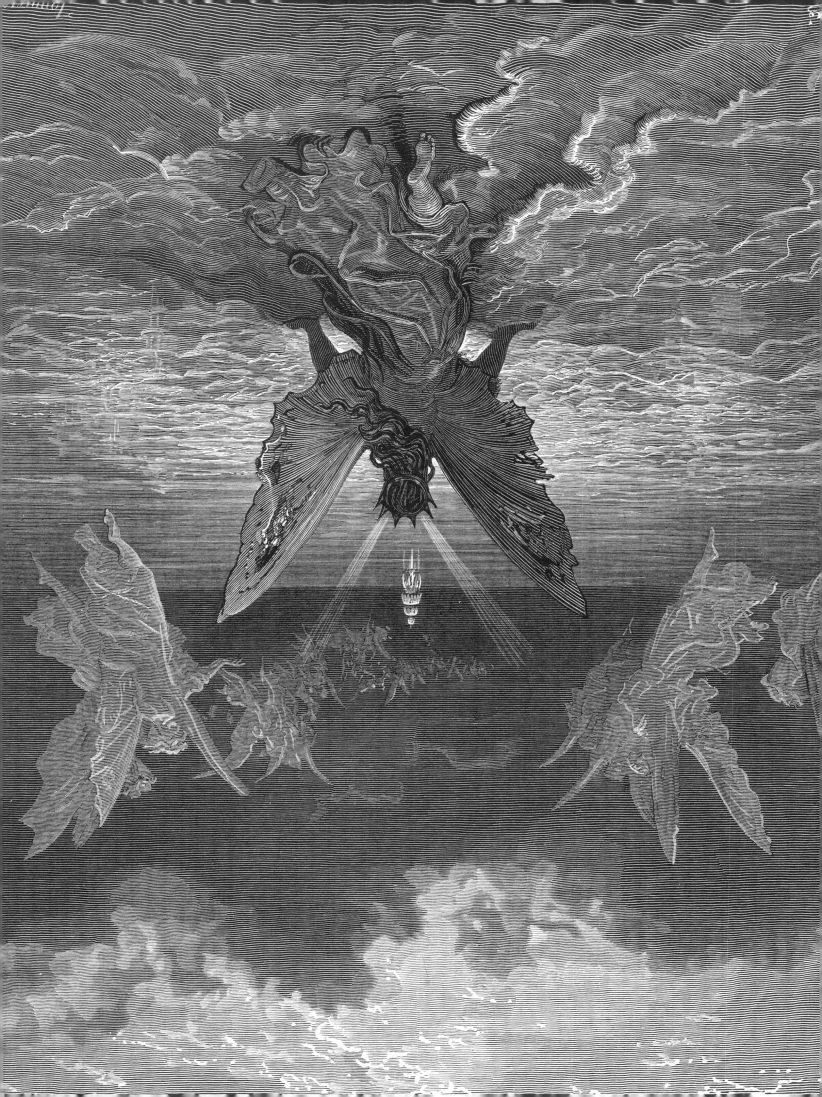

Under the keel nine fathom deep,
From the land of mist and snow,
The Spirit slid: and it was he
That made the ship to go.
The sails at noon left off their tune,
And the ship stood still also.

The Sun, right up above the mast,
Had fixed her to the ocean:
But in a minute she 'gan stir,
With a short uneasy motion—
Backwards and forwards half her length,
With a short uneasy motion.

Then like a pawing horse let go,
She made a sudden bound:
It flung the blood into my head,
And I fell down in a swound.

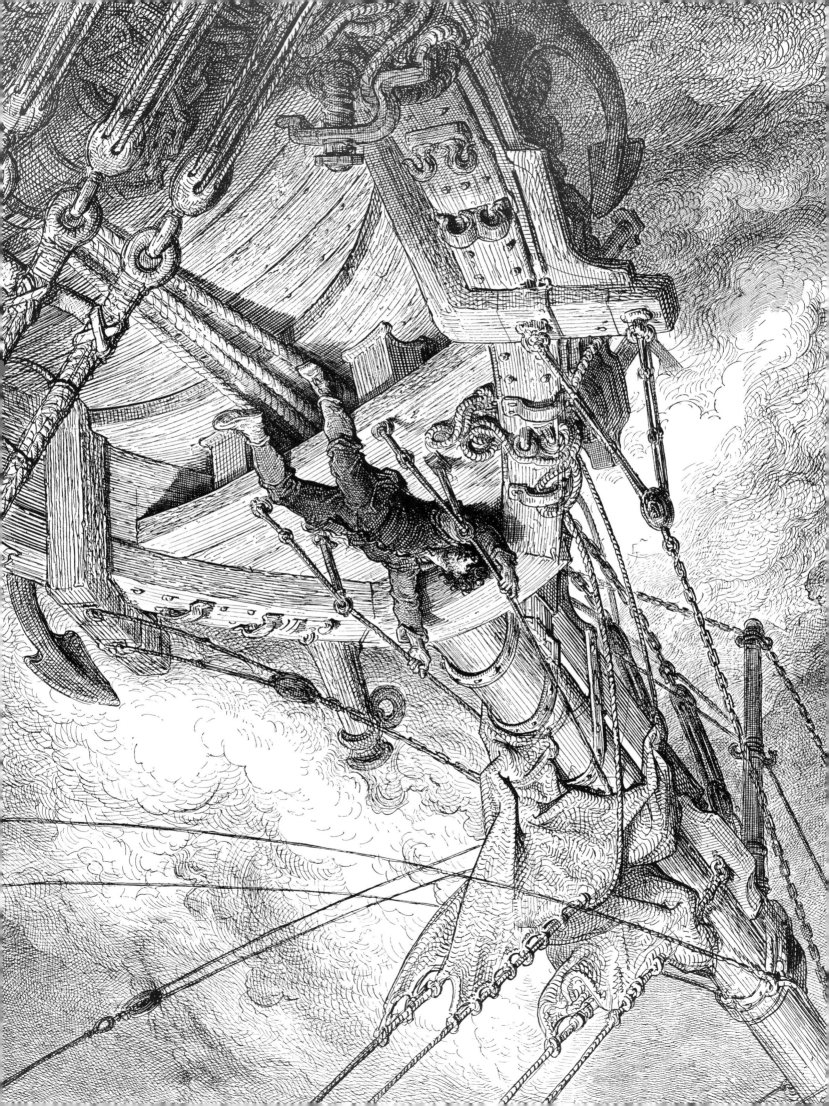

The Polar Spirit's fellow-demons, the invisible inhabitants of the element, take part in his wrong; and two of them relate, one to the other, that penance long and heavy for the ancient Mariner hath been accorded to the Polar Spirit, who returneth southward.

How long in that same fit I lay,
I have not to declare;
But ere my living life returned,
I heard, and in my soul discerned
Two VOICES in the air.

"Is it he?" quoth one, "Is this the man?
By Him who died on cross,
With his cruel bow he laid full low
The harmless Albatross.

"The spirit who bideth by himself
In the land of mist and snow,
He loved the bird that loved the man
Who shot him with his bow."

The other was a softer voice,
As soft as honey-dew:
Quoth he, "The man hath penance done,
And penance more will do."

PART THE SIXTH

FIRST VOICE.

BUT tell me, tell me! speak again,
Thy soft response renewing—
What makes that ship drive on so fast?
What is the OCEAN doing?

SECOND VOICE.

Still as a slave before his lord, *God*
The OCEAN hath no blast;
His great bright eye most silently
Up to the Moon is cast—

If he may know which way to go;
For she guides him smooth or grim.
See, brother, see! how graciously
She looketh down on him.

She— Life? Death?

The Mariner hath been cast into a trance; for the angelic power causeth the vessel to drive north-ward faster than human life could en-dure.

But why drives on that ship so fast,
Without or wave or wind?

SECOND VOICE.

The air is cut away before,
And closes from behind.

Fly, brother, fly! more high, more high!
Or we shall be belated:
For slow and slow that ship will go,
When the Mariner's trance is abated.

The supernat-ural motion is retarded; the Mariner awakes, and his penance begins anew.

I woke, and we were sailing on
As in a gentle weather:
'Twas night, calm night, the Moon was high;
The dead men stood together.

All stood together on the deck,
For a charnel-dungeon fitter:
All fixed on me their stony eyes,
That in the Moon did glitter.

once again he cannot pray because he's caught in a trance by the dead man's state

The pang, the curse, with which they died,
Had never passed away:
I could not draw my eyes from theirs,
Nor turn them up to pray.

The curse is finally expi-ated;

And now this spell was snapt; once more
I viewed the ocean green, the ocean is green again
And looked far forth, yet little saw
Of what had else been seen—

Like one, that on a lonesome road
Doth walk in fear and dread,
And having once turned round walks on,
And turns no more his head;
Because he knows a frightful fiend
Doth close behind him tread.

But soon there breathed a wind on me,
Nor sound nor motion made:
Its path was not upon the sea,
In ripple or in shade.

It raised my hair, it fanned my cheek
Like a meadow-gale of spring—
It mingled strangely with my fears,
Yet it felt like a welcoming.

Swiftly, swiftly flew the ship,
Yet she sailed softly too:
Sweetly, sweetly blew the breeze—
On me alone it blew.

And the an-
cient Mariner
beholdeth his
native country.
Oh! dream of joy! is this indeed
The light-house top I see? Protection
Is this the hill? is this the kirk?
Is this mine own countree?

We drifted o'er the harbor-bar,
And I with sobs did pray—
O let me be awake, my God! live or
Or let me sleep alway. die

The harbor-bay was clear as glass,
So smoothly it was strewn!
And on the bay the moonlight lay,
And the shadow of the Moon.

The rock shone bright, the kirk no less,
That stands above the rock:
The moonlight steeped in silentness
The steady weathercock.

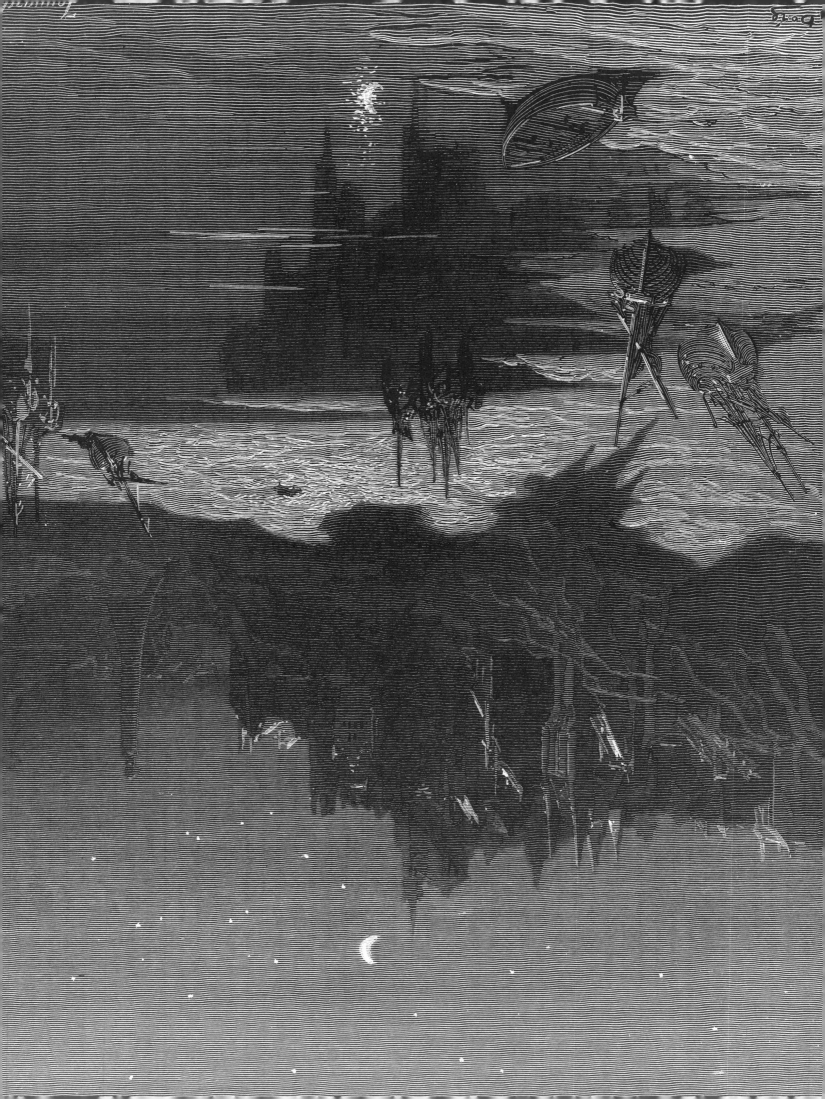

And the bay was white with silent light,
Till rising from the same,
Full many shapes, that shadows were,
In crimson colors came.

The angelic spirits leave the dead bodies,

A little distance from the prow
Those crimson shadows were :
I turned my eyes upon the deck—
Oh, Christ ! what saw I there !

And appear in their own forms of light.

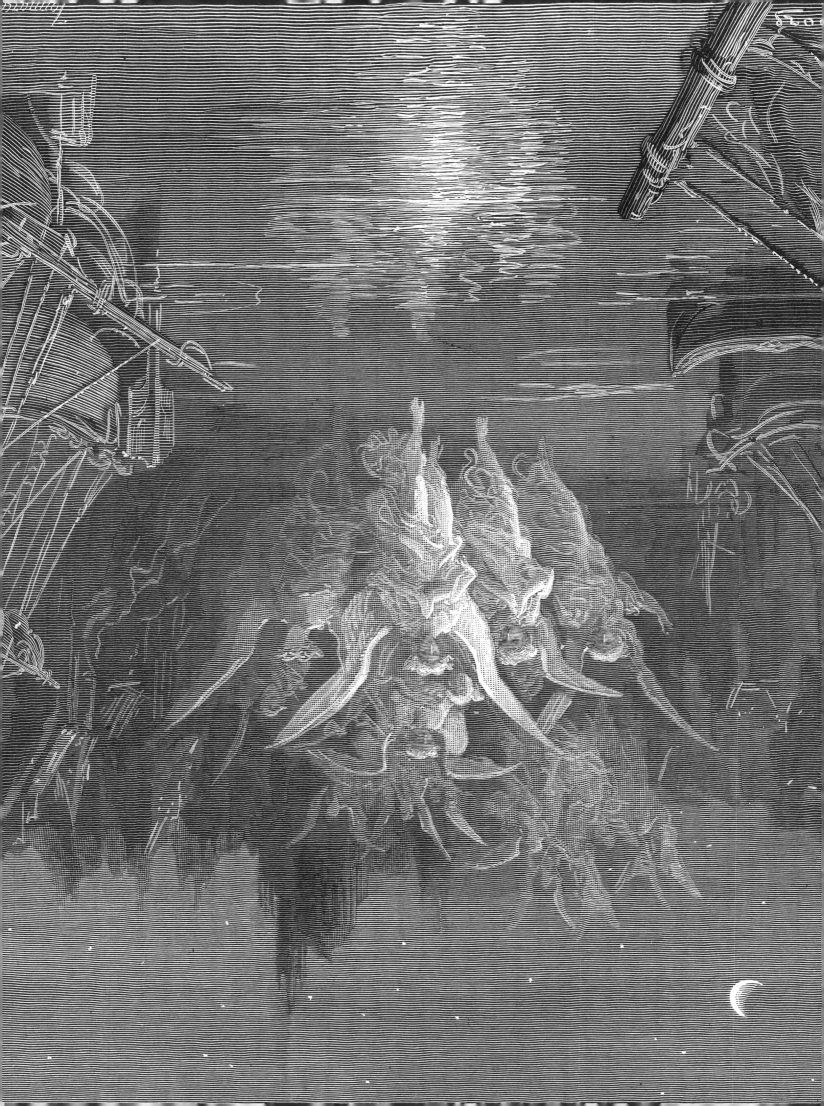

each shipmate became a Seraph

Each corse lay flat, lifeless and flat,
And, by the holy rood!
A man all light, a seraph-man,
On every corse there stood.

This seraph-band, each waved his hand:
It was a heavenly sight!
They stood as signals to the land,
Each one a lovely light;

Symbols of Safety

Kirk
Pilot

This seraph-band, each waved his hand,
No voice did they impart—
No voice; but oh! the silence sank
Like music on my heart.

But soon I heard the dash of oars,
I heard the Pilot's cheer;
My head was turned perforce away,
And I saw a boat appear.

The Pilot and the Pilot's boy,
I heard them coming fast:
Dear Lord in Heaven! it was a joy
The dead men could not blast.

Shriev- to clean;
Clear

relates to religion

I saw a third—I heard his voice:
It is the Hermit good!
He singeth loud his godly hymns
That he makes in the wood.
He'll shrieve my soul, he'll wash away
The Albatross's blood.

58

PART
THE SEVENTH

THIS Hermit good lives in that wood
 Which slopes down to the sea.
How loudly his sweet voice he rears!
He loves to talk with marineres
That come from a far countree.

He kneels at morn, and noon and eve—
He hath a cushion plump:
It is the moss that wholly hides
The rotted old oak-stump.

The skiff-boat neared: I heard them talk,
" Why, this is strange, I trow!
Where are those lights so many and fair,
That signal made but now?"

" Strange, by my faith!" the Hermit said—
" And they answered not our cheer!
The planks look warped! and see those sails,
How thin they are and sere!
I never saw aught like to them,
Unless perchance it were

Religion

" Brown skeletons of leaves that lag
My forest-brook along;
When the ivy-tod is heavy with snow,
And the owlet whoops to the wolf below,
That eats the she-wolf's young."

" Dear Lord! it hath a fiendish look"
(The Pilot made reply)—
" I am a-feared—" " Push on, push on!"
Said the Hermit cheerily.

The boat came closer to the ship,
But I nor spake nor stirred;
The boat came close beneath the ship,
And straight a sound was heard.

Under the water it rumbled on,
Still louder and more dread:
It reached the ship, it split the bay;
The ship went down like lead.

Compared to the albatross as well, the bird and boat are a curse

Stunned by that loud and dreadful sound,
Which sky and ocean smote,
Like one that hath been seven days drowned
My body lay afloat;
But swift as dreams, myself I found
Within the Pilot's boat.

The ancient Mariner is saved in the Pilot's boat.

a whirlpool out of no where destroys the boat

Upon the whirl, where sank the ship,
The boat spun round and round;
And all was still, save that the hill
Was telling of the sound.

I moved my lips—the Pilot shrieked
And fell down in a fit;
The holy Hermit raised his eyes,
And prayed where he did sit.

I took the oars: the Pilot's boy,
Who now doth crazy go,
Laughed loud and long, and all the while
His eyes went to and fro.
{ "Ha! ha!" quoth he, "full plain I see
The Devil knows how to row."

And now, all in my own countree,
I stood on the firm land!
The Hermit stepped forth from the boat,
And scarcely he could stand.

*The ancient
Mariner ear-
nestly entreat-
eth the Hermit
to shrieve him;
and the pen-
ance of life
falls on him.*

" O shrieve me, shrieve me, holy man !"
The Hermit crossed his brow.
" Say quick," quoth he, " I bid thee say—
What manner of man art thou ?"

Forthwith this frame of mine was wrenched
With a woful agony,
Which forced me to begin my tale;
And then it left me free.

And ever and anon throughout his future life an agony constraineth him to travel from land to land,

Since then, at an uncertain hour,
That agony returns :
And till my ghastly tale is told,
This heart within me burns.

he feels physical pain until he tells his tale

68

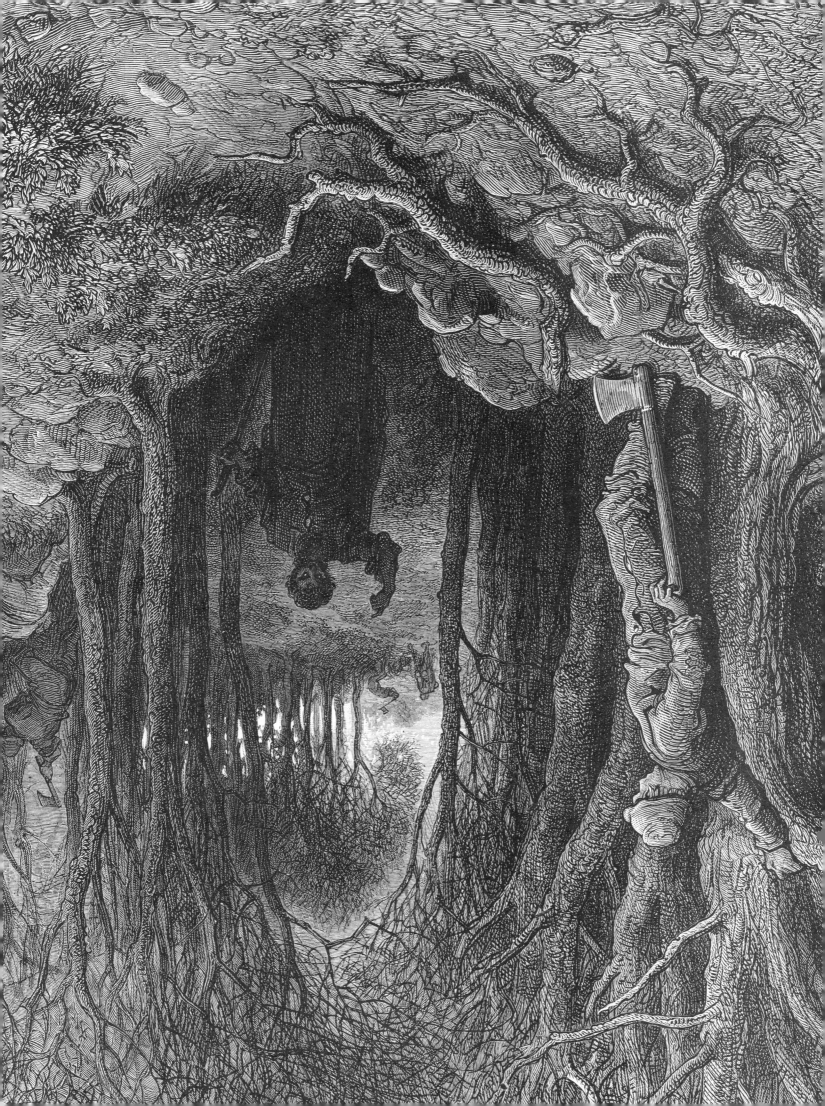

I pass, like night, from land to land;
I have strange power of speech;
That moment that his face I see,
I know the man that must hear me:
To him my tale I teach.

What loud uproar bursts from that door!
The wedding-guests are there:
But in the garden-bower the bride
And bride-maids singing are:
And hark the little vesper bell,
Which biddeth me to prayer!

O Wedding-Guest! this soul hath been
Alone on a wide wide sea:
So lonely 'twas, that God himself
Scarce seeméd there to be.

O sweeter than the marriage-feast,
'Tis sweeter far to me,
To walk together to the kirk
With a goodly company!—

To walk together to the kirk, *he's now open to*
And all together pray, *pray freely*
While each to his great Father bends,
Old men, and babes, and loving friends
And youths and maidens gay!

*And to teach,
by his own ex-
ample, love
and reverence
to all things
that God made
and loveth.*

*The moral of
the Story*

Farewell, farewell! but this I tell
To thee, thou Wedding-Guest!
He prayeth well, who loveth well
Both man and bird and beast.

He prayeth best, who loveth best
All things both great and small;
For the dear God who loveth us,
He made and loveth all.

74

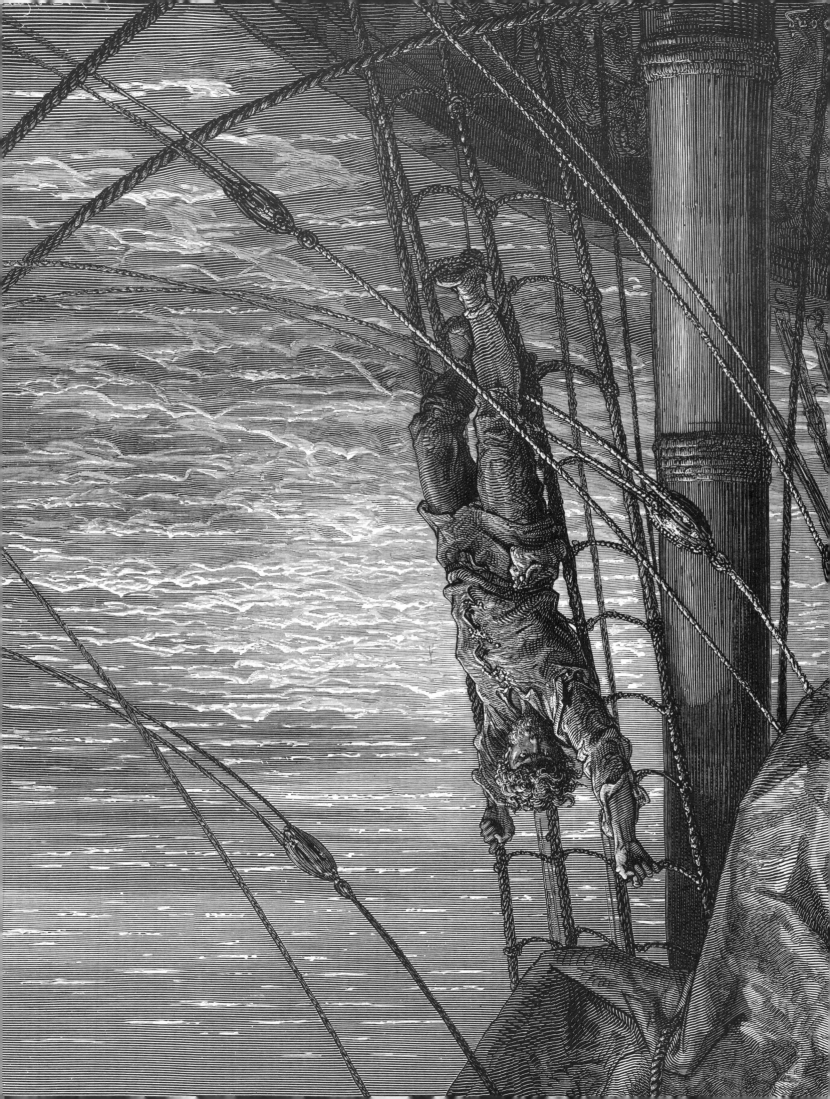

The Mariner, whose eye is bright,
Whose beard with age is hoar,
Is gone : and now the Wedding-Guest
Turned from the Bridegroom's door.

He went like one that hath been stunned,
And is of sense forlorn :
A sadder and a wiser man,
He rose the morrow morn.